a seal named patches

Roxanne Beltran and Patrick Robinson

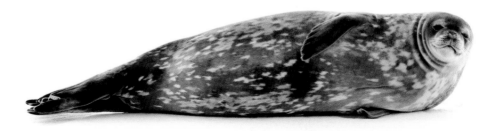

University of Alaska Press

Fairbanks

McMurdo Station, located on Ross Island, Antarctica, is a United States research facility operated by the National Science Foundation. It is the home base for many science projects each year (biologists, geologists, glaciologists, oceanographers, and atmospheric scientists stay here while they do their research). Up to 1,000 people live at McMurdo during the Antarctic summer months (August to February). Only about 150 people live here in the winter (March to July).

Dedicated to Mary Zavanelli
for teaching us to keep running no matter how far the finish line

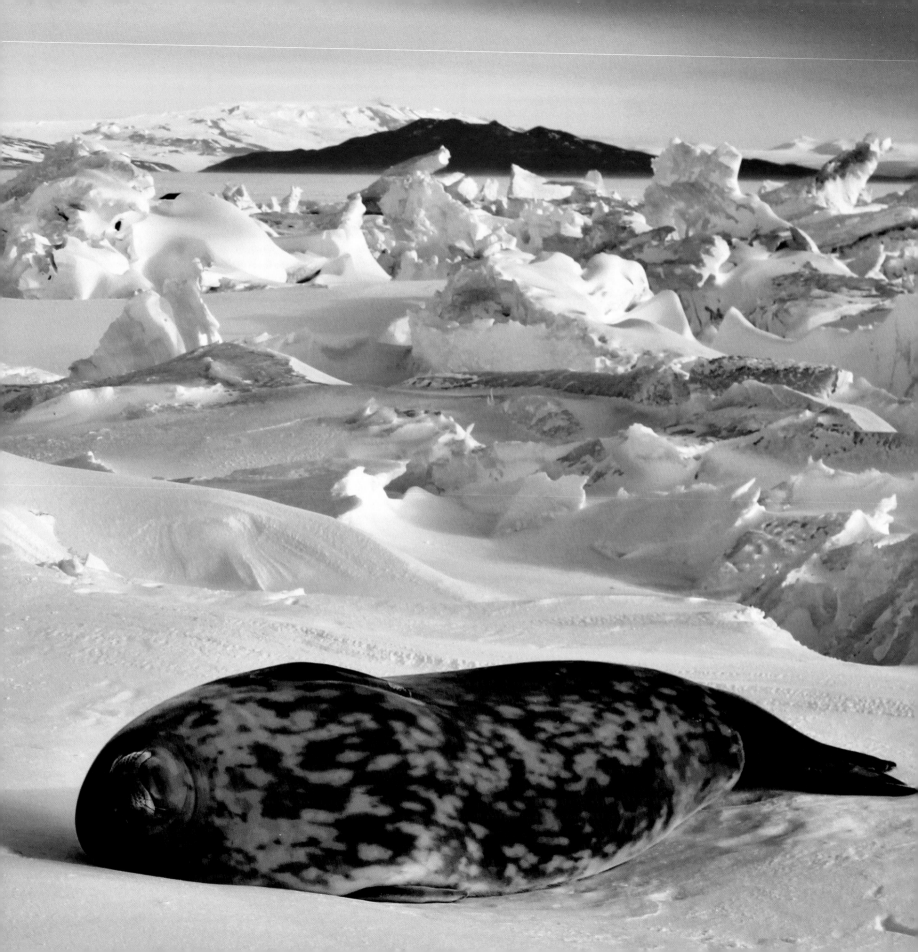

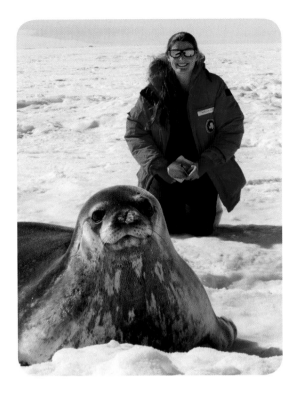

Have you ever wondered what's at the bottom of the world?

Not many people have been there, but we have! We are scientists and we study seals in Antarctica. We want to learn how one species, the Weddell seal, finds enough food to survive.

Studying Weddell seals is challenging because they spend most of their time underwater.

Weddell seals are the most southern breeding mammal. Scientists study the seals because they inhabit an underwater ecosystem that has experienced the least human disturbance of any on Earth.

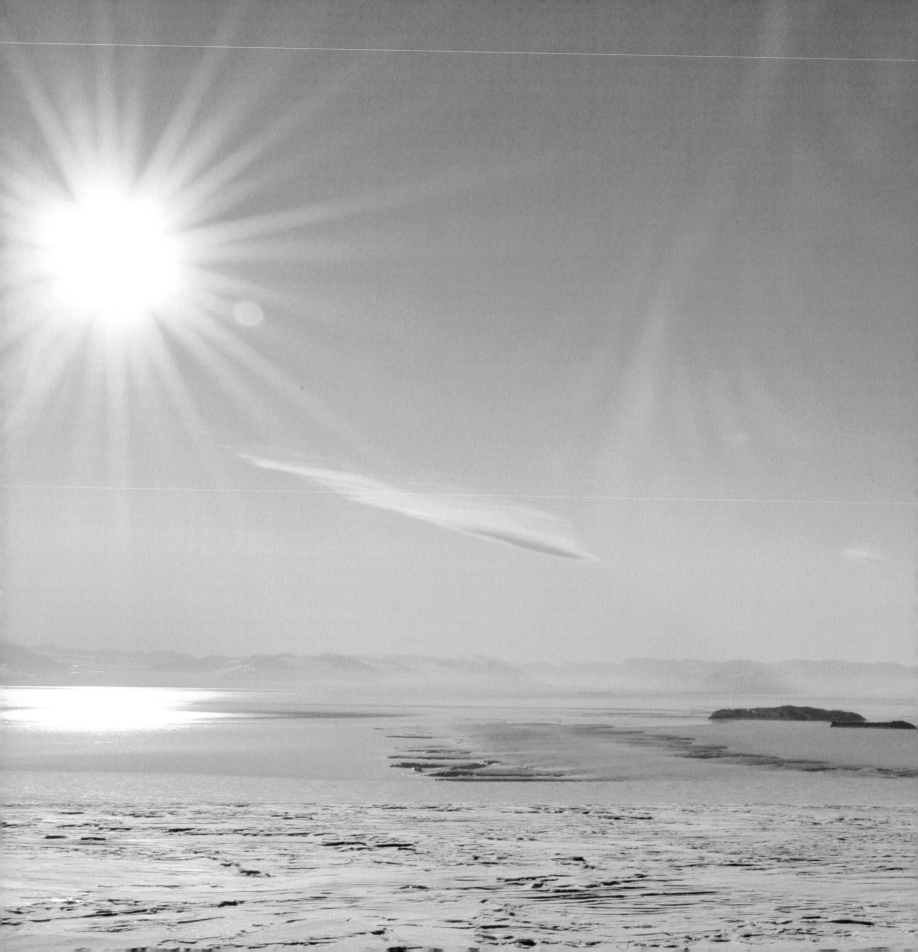

We travel to Antarctica during the summer, which is between August and February in the southern hemisphere. The air temperature is between 0 and 30 degrees Fahrenheit—that's as cold as your freezer at home!

Because we are so close to the South Pole, the sun doesn't set for four straight months. We have daylight twenty-four hours a day, seven days a week.

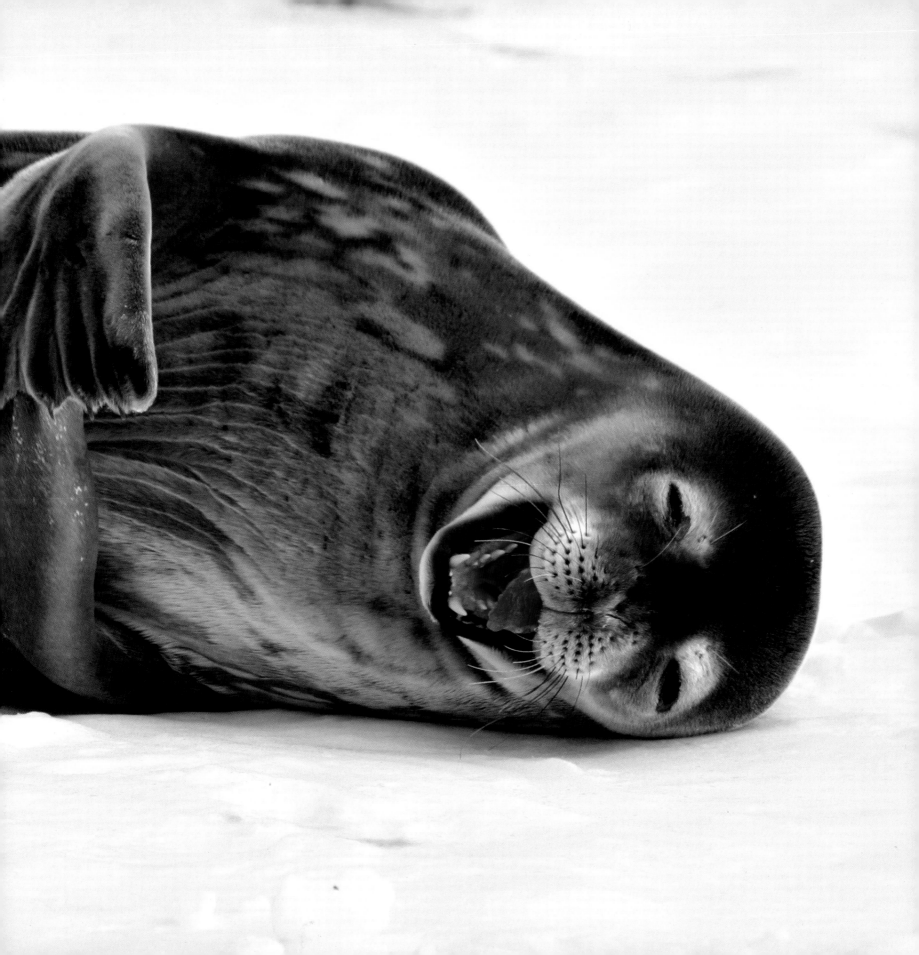

As part of our science project this year, our team has an important job: we are searching for one special Weddell seal that we have seen every year since she was born.

At 30 years old, this remarkable seal is one of the oldest seals ever studied.

Her name is Patches, and this is her story.

The Ross Sea in Antarctica was recently declared an official Marine Protected Area, which prohibits fishing in most regions. This protected area—the largest in the world—will allow scientists to study the pristine ecosystem and compare its baseline dynamics to those near other continents.

One reason Patches is special is because she has lived so long on such a harsh continent.

Only one out of every five baby Weddell seals, or pups, survives long enough to have a pup of its own about seven years later.

Patches has given birth to twenty-one pups over her lifetime—can you believe that?

Patches holds the record as the most successful mom in Weddell seal history.

Most Weddell seal moms live to be about 15 years old (which means they usually give birth to five or fewer pups throughout their lives).

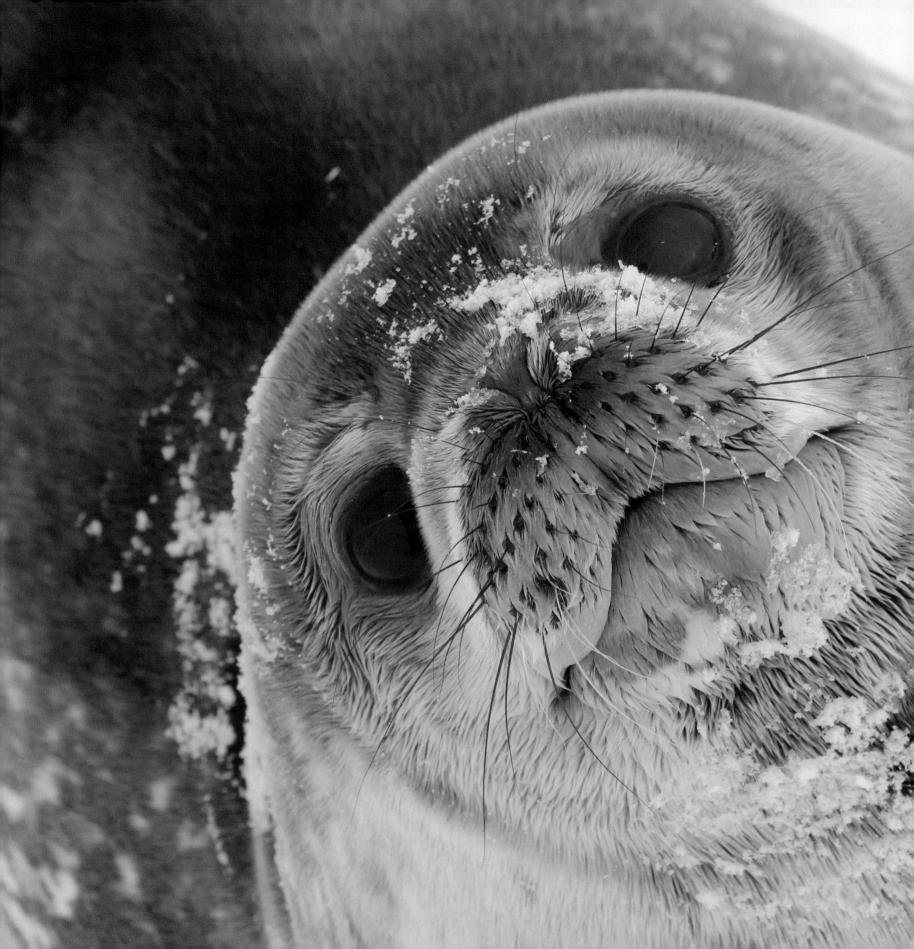

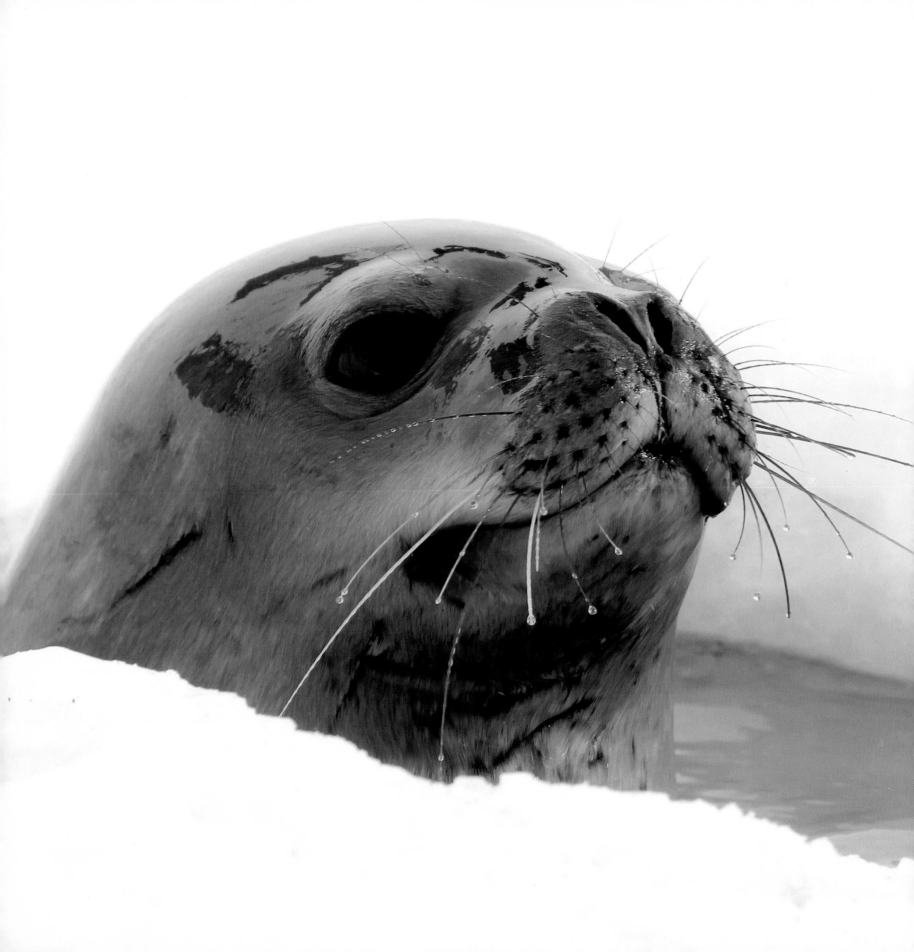

We need to find Patches so we can see if she is healthy. We know that Patches is healthy if she has a pup each year.

In bad years, there aren't enough fish for Patches to eat, so she doesn't have a pup.

In good years, there are plenty of fish for Patches to eat, and she weighs around 1,000 pounds. During these years, Patches has a pup and feeds it lots of milk. If we see Patches with a pup, we know it has been a good year for the Weddell seals.

Will Patches give birth to her twenty-second pup this year? It's our mission to find out, but first we need to find her!

Weddell seal moms that can't find enough food during the winter are skinnier while nursing, so they give less milk to their pups. The skinnier pups then have a disadvantage compared to other pups.

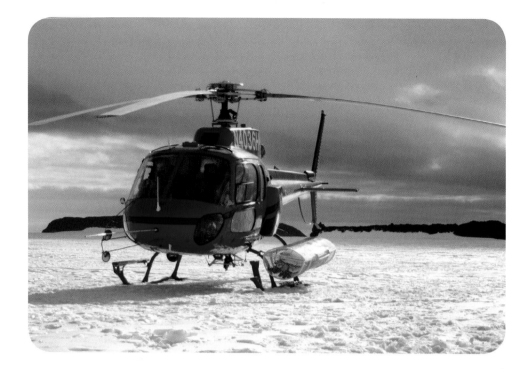

We will have to travel many miles during our search for Patches. To find her, we fly in a helicopter and look for groups of Weddell seals that are resting on the ice surface.

We wake up early and spend as much time as we can looking for seals.

Helicopters can fly at speeds of 115 miles per hour! Antarctica's helicopter pilots are highly trained, each flying about 300 hours of science missions during a single summer. Altogether, McMurdo Station's five helicopters move more than 1 million pounds of cargo each year.

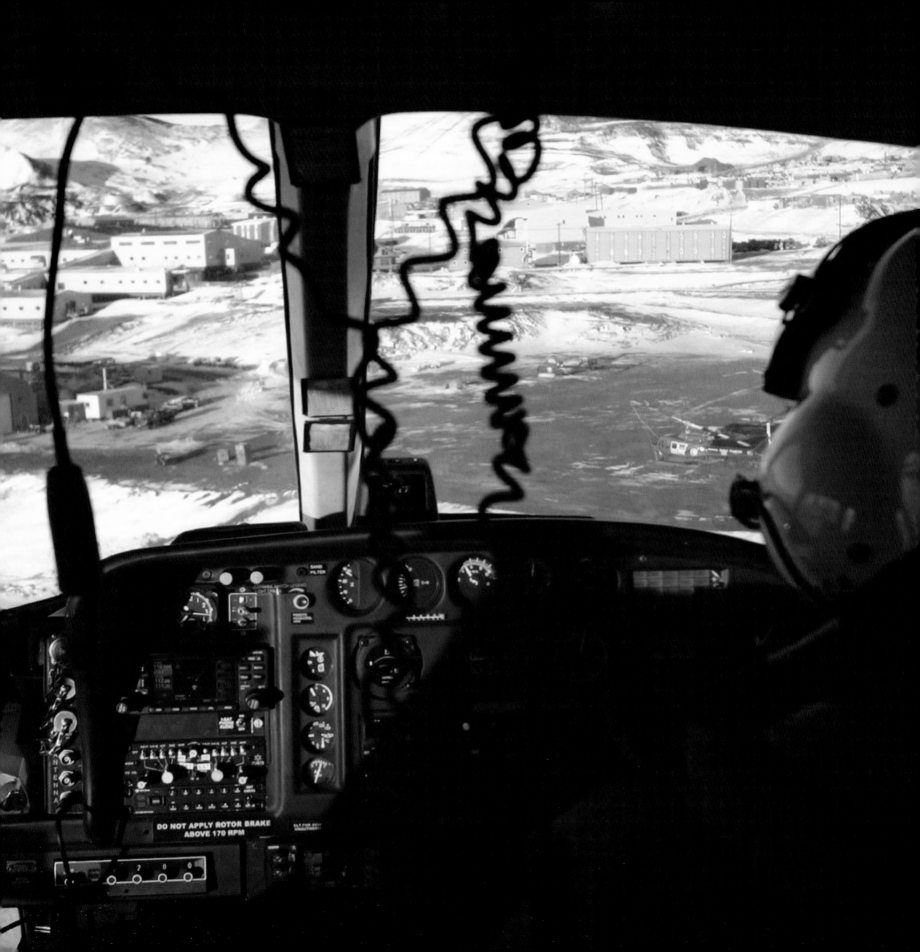

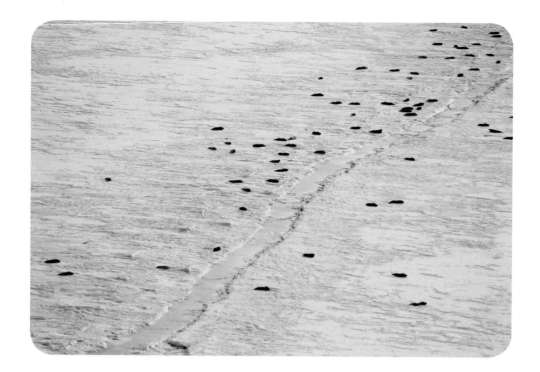

We see so many amazing views from the helicopter!

We see enormous mountains covered in snow.

We see beautiful glaciers like walls of ice.

We see hundreds and hundreds of Weddell seals. There are so many seals!

How will we ever be able to find Patches?

Patches is one of about 2,000 Weddell seals that live near McMurdo Station. The seal population is healthy and stable here.

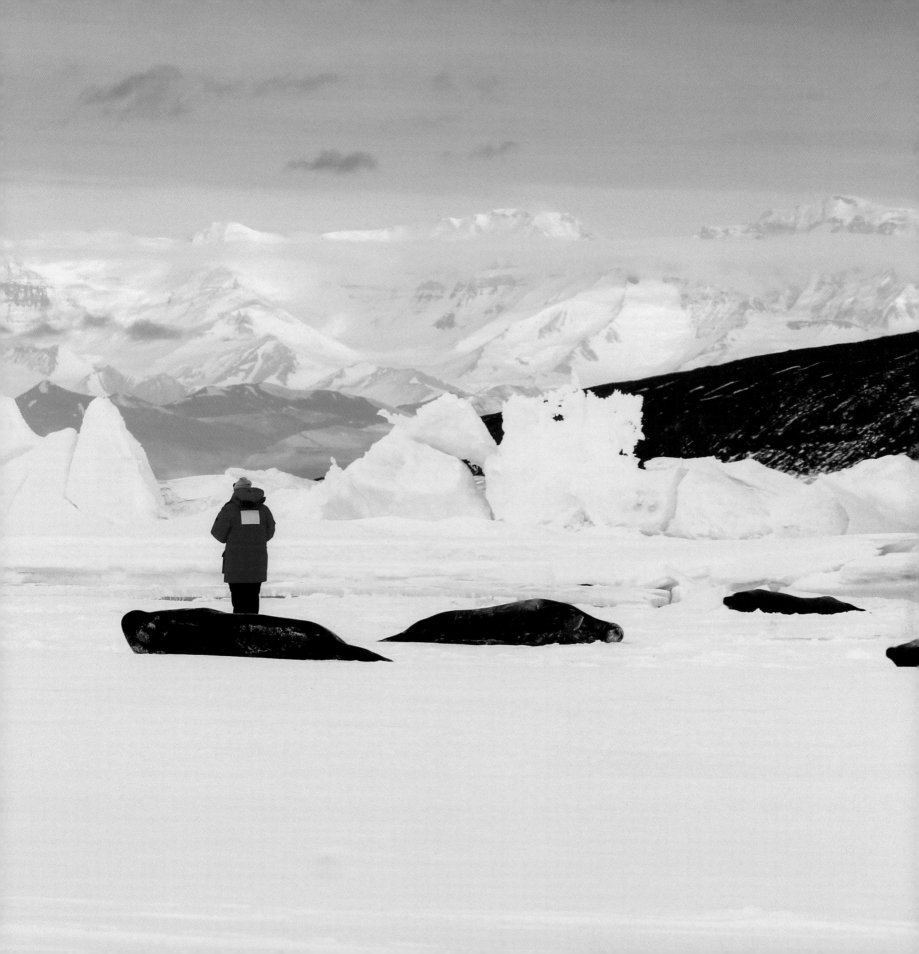

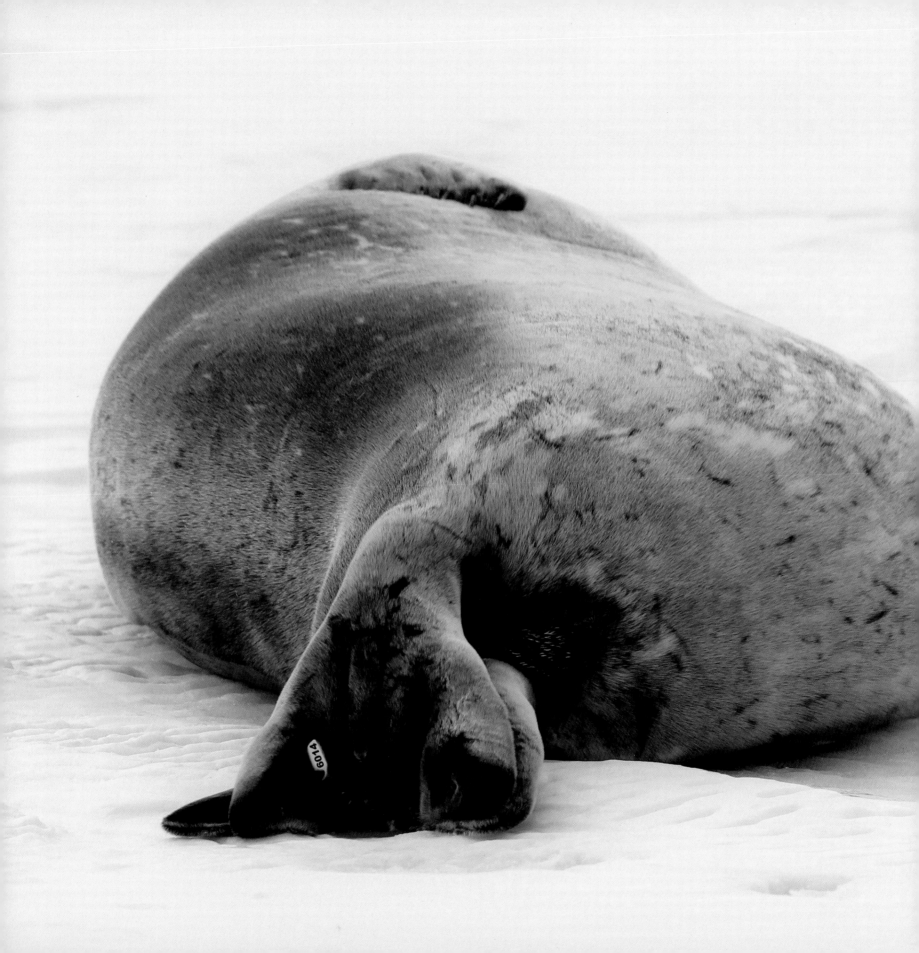

We will know we've found Patches when we see her flipper tag.

Each Weddell seal has a flipper tag with a unique number. These flipper tags can help our team of scientists find the same seals every year.

Patches has a flipper tag that says '6014.'

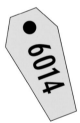

Flipper tags are put into the soft webbing between the seals' toes. When a tag is attached, the seal feels a quick pinch, sort of like getting your ears pierced.

The helicopter flies above many miles of sea ice and lands near a group of Weddell seals.

We jump out of the helicopter to look for Patches.

One by one, we walk up to each seal and use binoculars to read the numbers on their flipper tags.

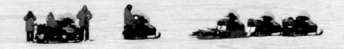

Although we search far and wide, none of the flipper tags have '6014' on them.

Our team is disappointed.

Patches isn't here.

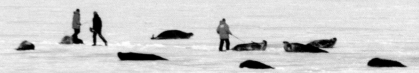

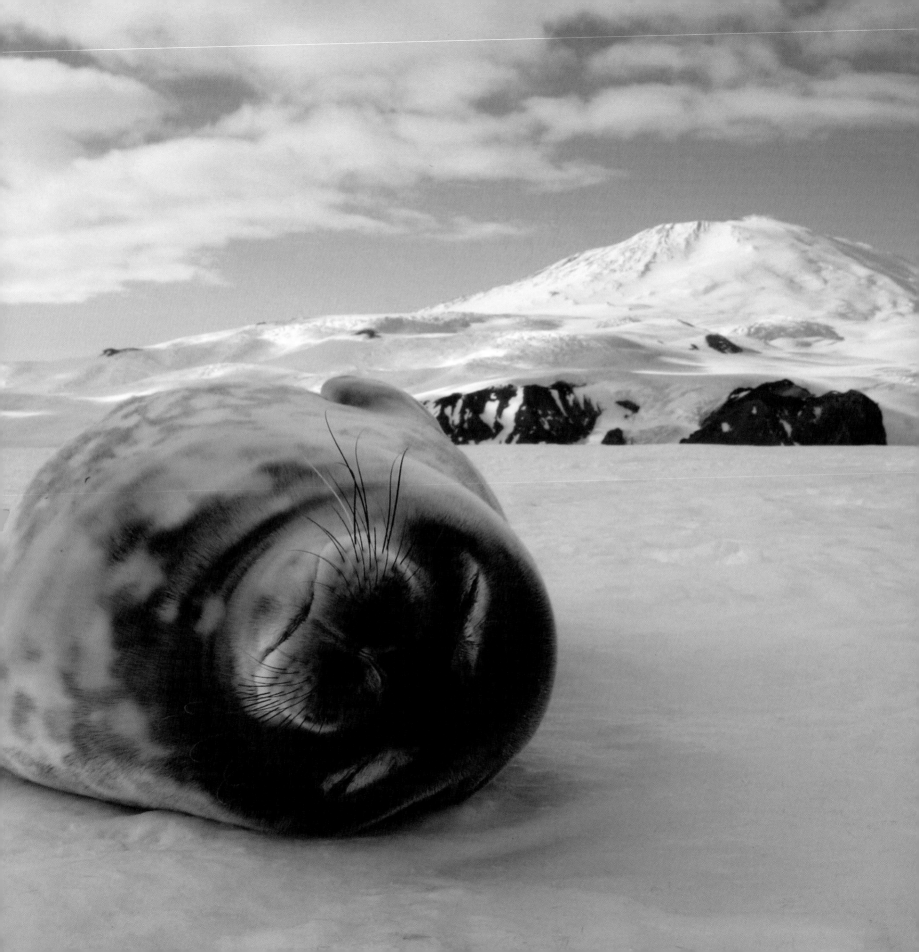

We look far and wide for Patches over many days. We see seal after seal, and tag after tag, but Patches is nowhere to be found.

We start to worry about Patches.

If Patches is not on the ice, where could she be? Could Patches be underwater?

This Weddell seal lays on the sea ice near Mount Erebus, a 12,451-foot-tall mountain in Antarctica and the most southern active volcano in the world.

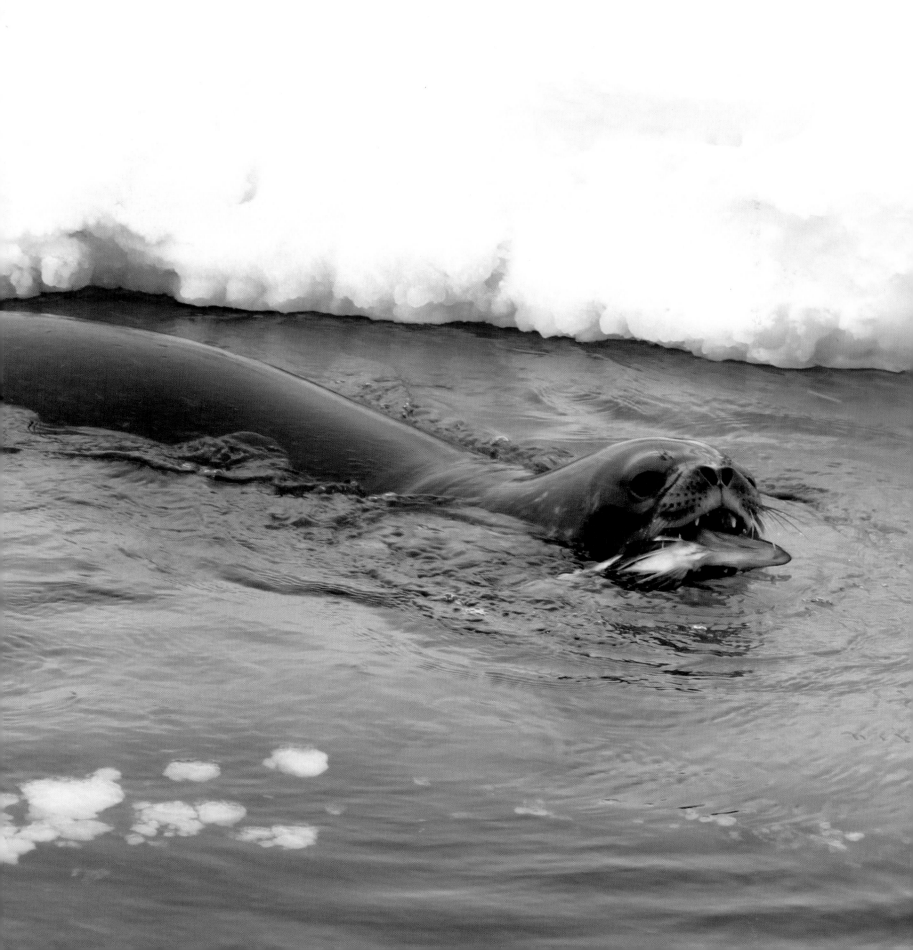

If Patches is underwater, we won't be able to see her. Weddell seals can stay underwater for an hour and a half looking for fish!

Patches' whiskers can feel water vibrations created by a fish as it swims nearby. When she senses a fish, she can chase the fish and grab it with her strong teeth.

Patches could be swimming! We'll have to be patient and wait for Patches to come out of the water.

Sometimes seals bite and swallow fish underwater while holding their breath. Other times they bring the fish up to the surface to eat. Weddell seals can eat up to twenty fish all on one dive.

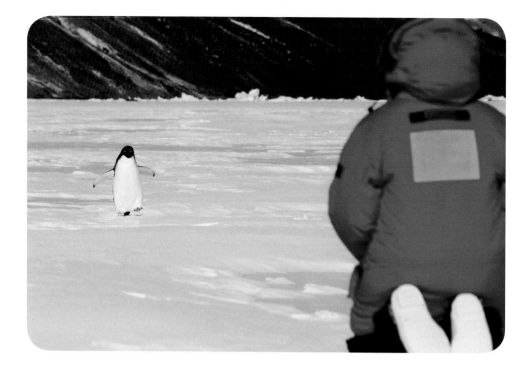

While we wait for Patches to come out of the water and rest on the snow, we take a break and enjoy the natural beauty of Antarctica.

Some days, we watch curious penguins explore the ice.

We see two species of penguins near the Weddell seal colonies: emperor penguins (right) and adelie penguins (above). Sometimes the penguins walk up to us and say hello with a big, loud voice that sounds like an old car trying to get started.

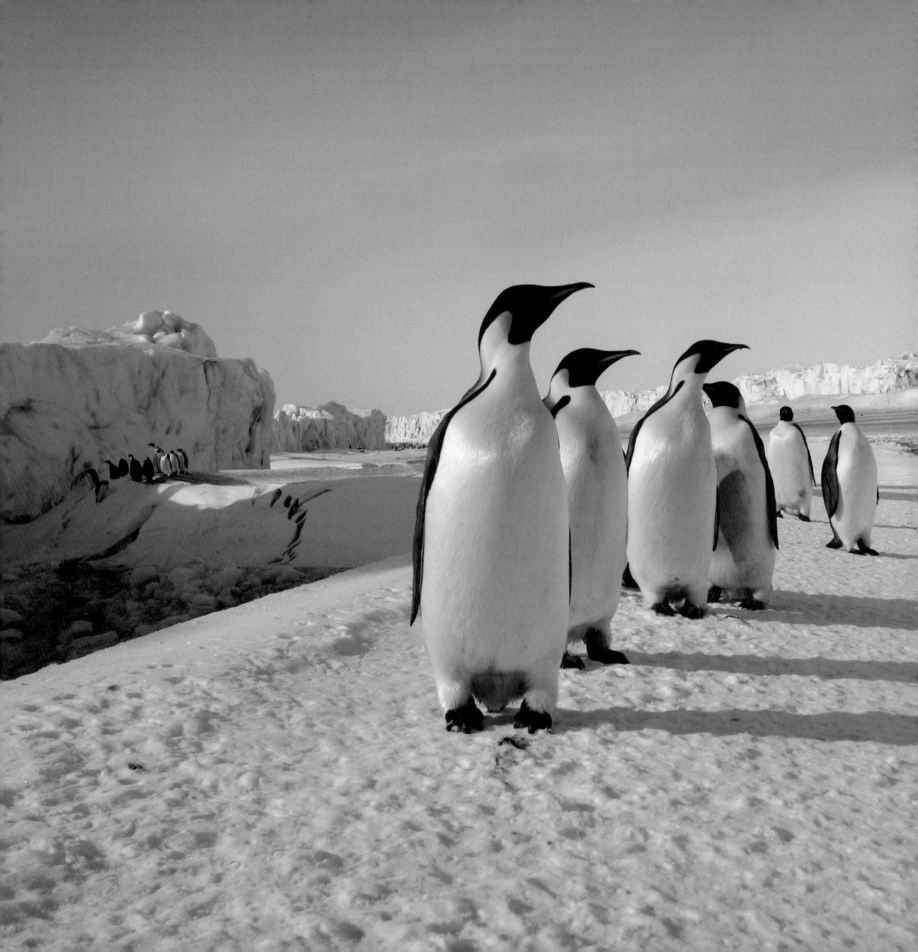

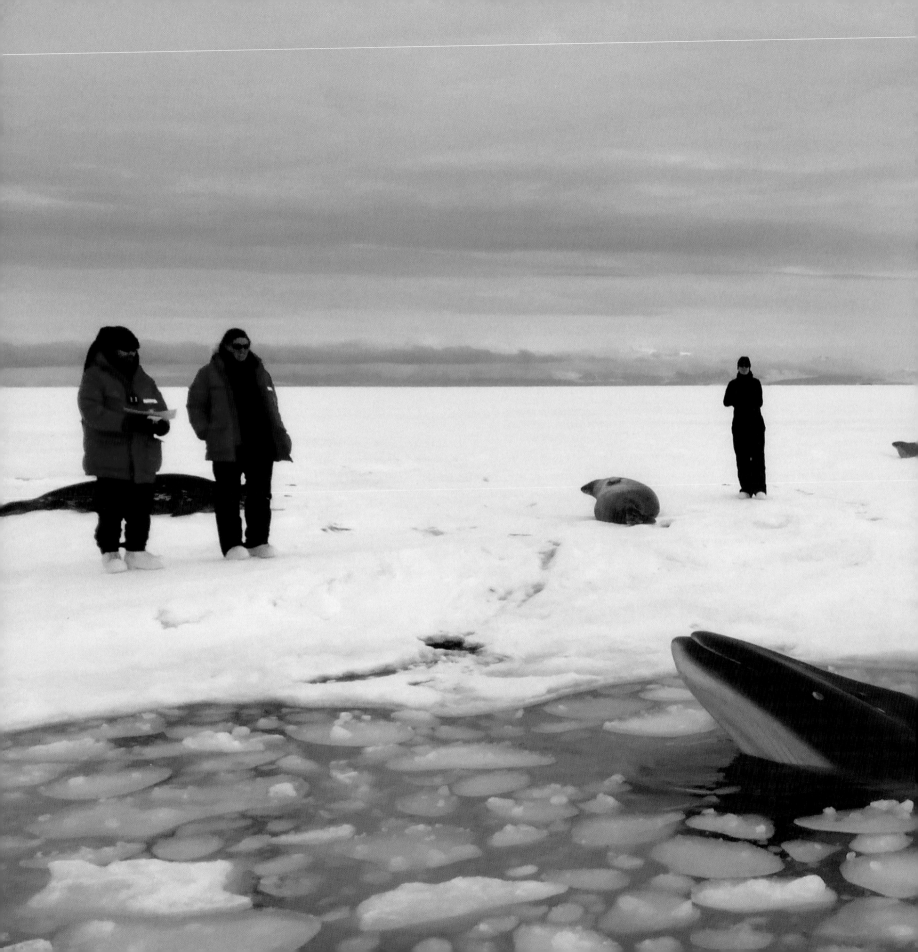

Some days, we are lucky enough to see a minke whale come up to the surface and take a breath.

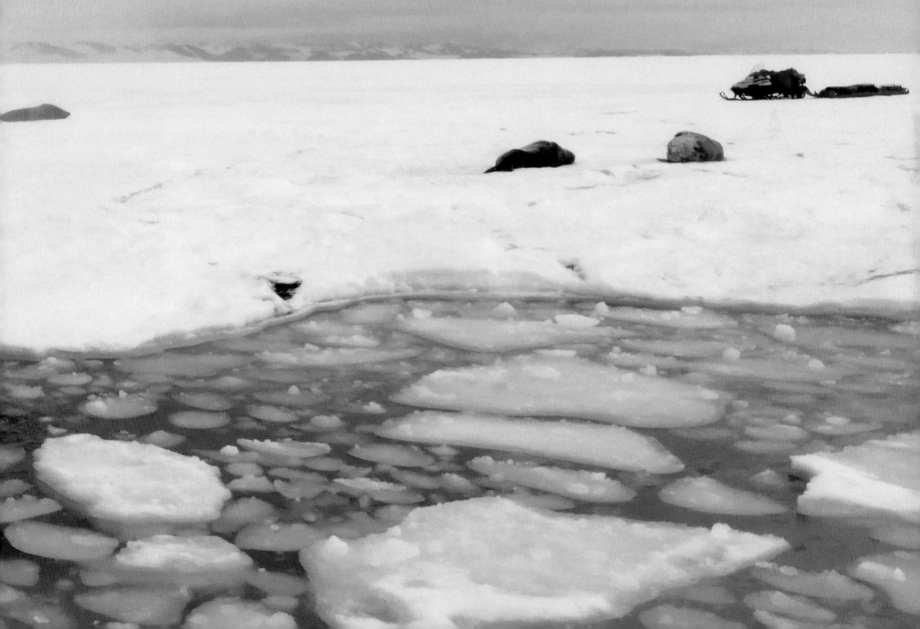

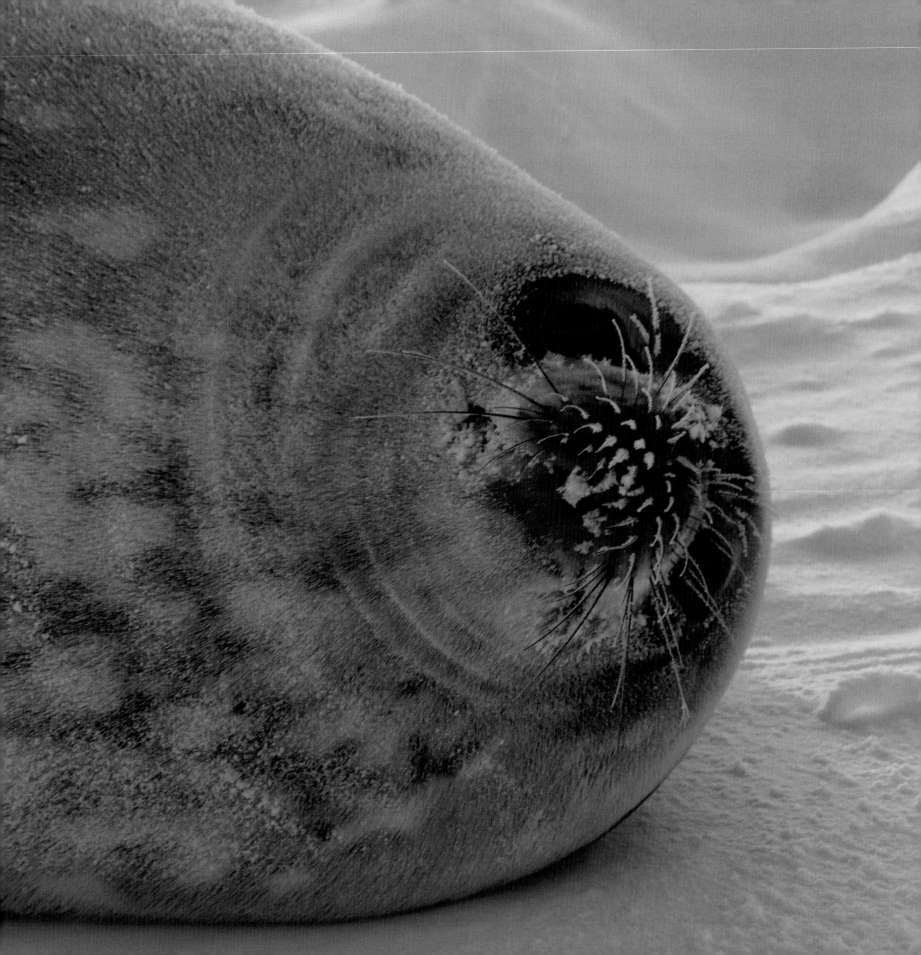

Antarctica is beautiful, but it's very cold!

Some days, the air is so cold that our fingers get numb.

But even on the coldest, windiest days, the seals are able to stay warm because they have a thick layer of fat, or blubber, to keep them warm.

Antarctica is so cold that even the ocean surface freezes over—the seawater can be below 30 degrees Fahrenheit. Weddell seals are about 40 percent fat to help them stay warm.

We watch and wait.

Every day, we hope that we will see Patches.

Every day, we are disappointed.

We read the flipper tags of more than 800
Weddell seals. We fear that Patches will
never be found.

Could Patches be swimming?

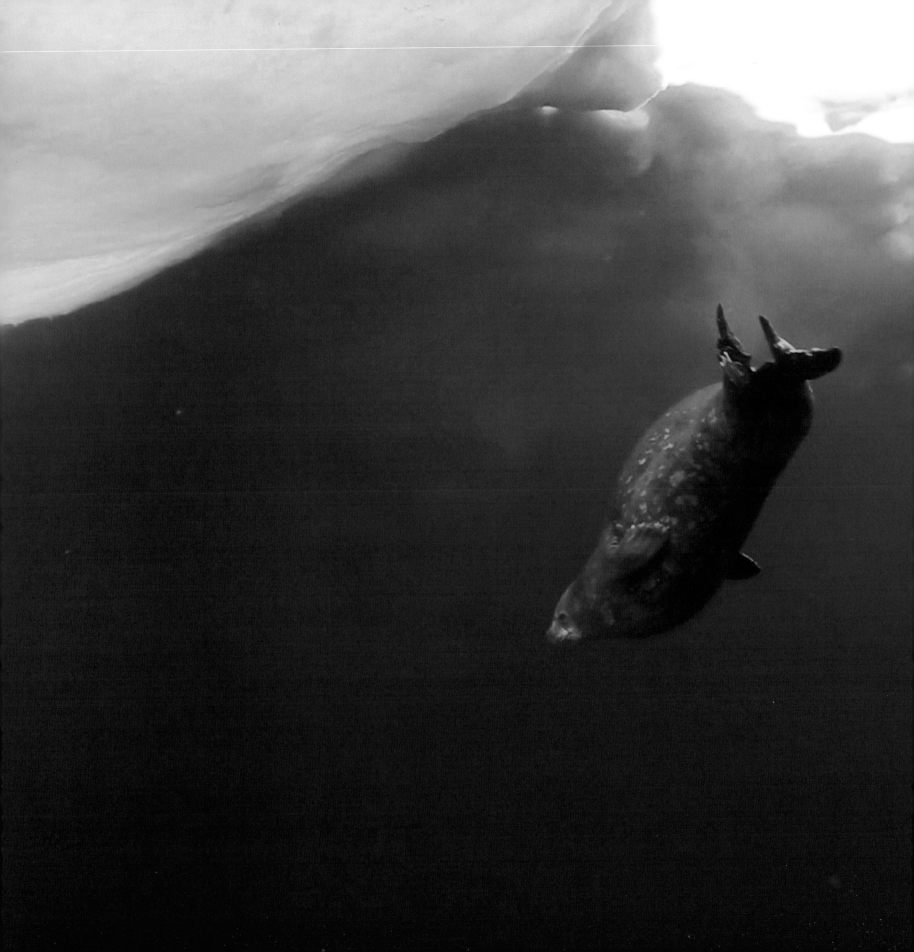

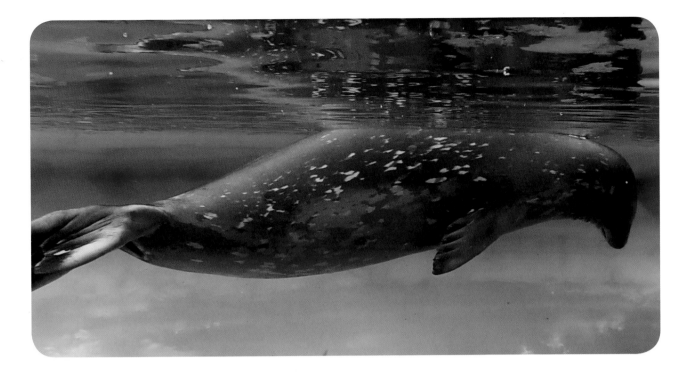

If Patches is swimming, it will be hard to find her.

When Patches gets back to the surface of the water after a long dive, she will catch her breath for a couple minutes and then dive again, over and over until she can't swim anymore.

When Patches gets tired and comes out of the water to rest, we will have a chance to find her.

Weddell seals can dive 3,000 feet underwater. That's the height of a 300-story building!

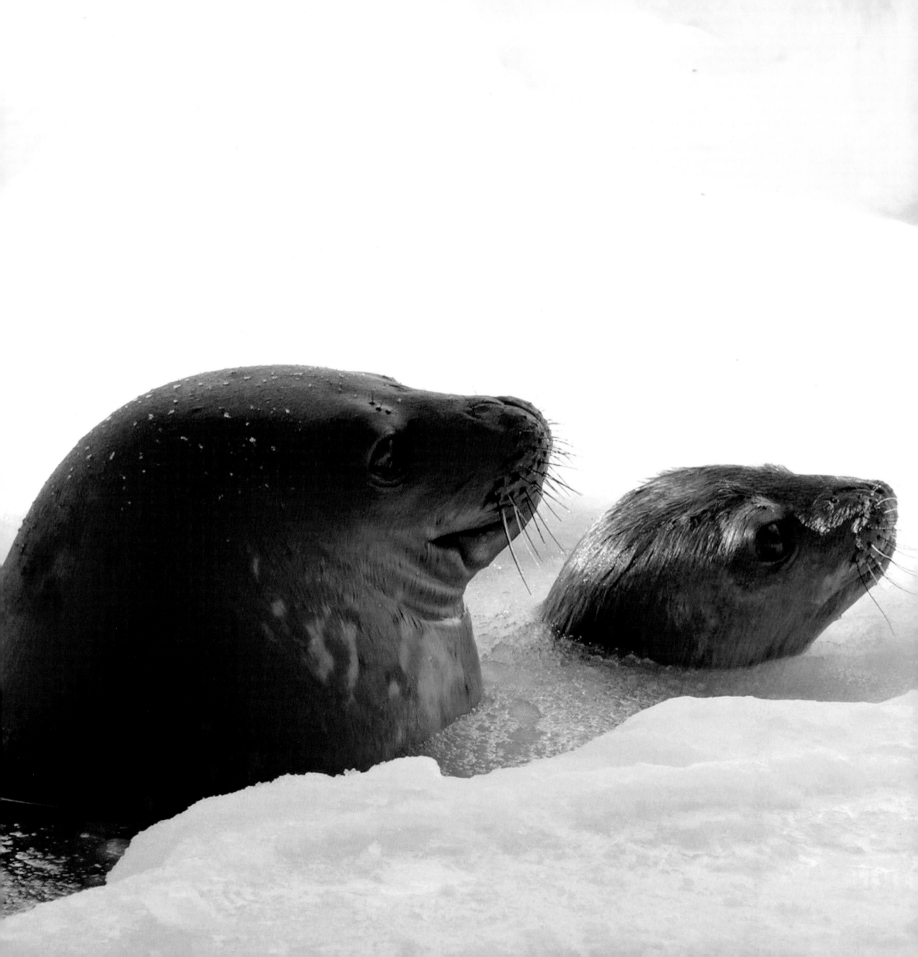

After two weeks of searching, it's our last day in Antarctica.

We must try one more time to find Patches.

We see a Weddell seal mom and pup rise to the water surface and look toward us.

Could that be Patches?

Weddell seals can live to be 33 years old. They tend to come back to the same place to have their pups, so scientists are usually able to find the same seals year after year.

The seal comes out of the water to rest on the ice.

We check her flipper tags and can't believe our eyes. It says '6014'!

The seal is Patches!

This Weddell seal population has been studied for nearly fifty consecutive years, and more than 80 percent of the seals in the population are uniquely identified using flipper tags. Of the 800,000 Weddell seals living around Antarctica, the seals living next to McMurdo Station are the most well-studied.

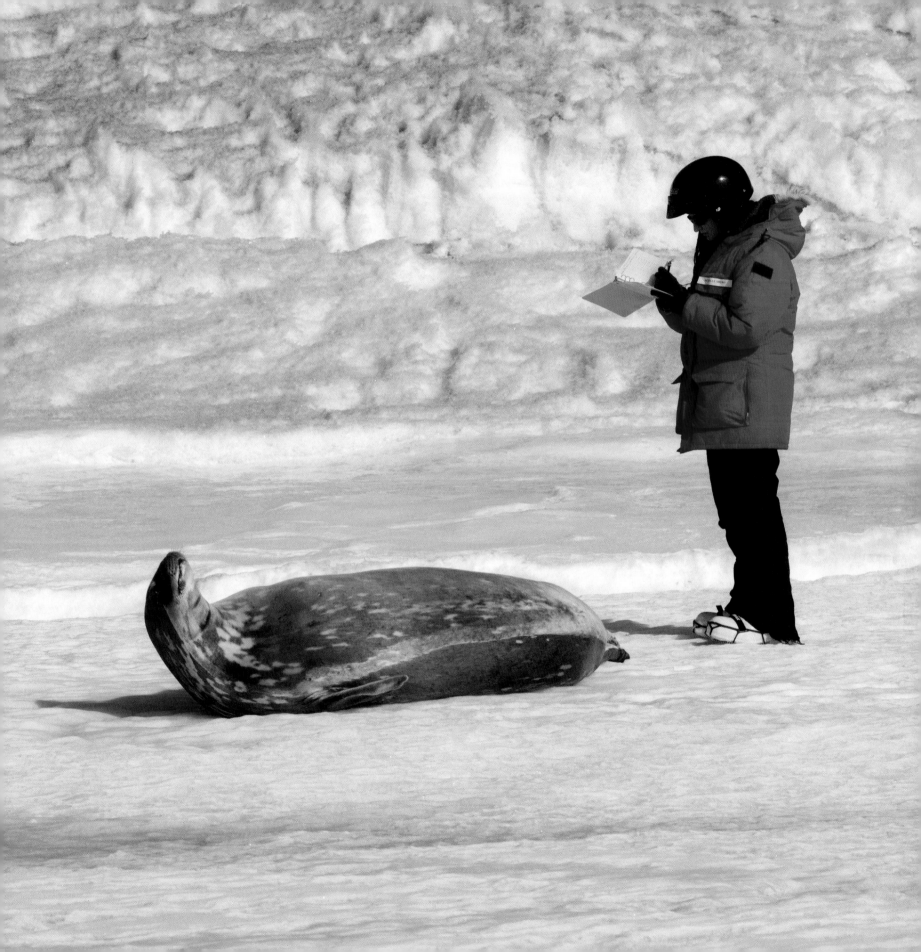

A few seconds later, the pup comes out of the water, too. We name him "Ollie." Based on his size, he is three weeks old and weighs around 150 pounds.

Ollie is snuggling Patches so we know that he is Patches' pup!

We think Patches was teaching him how to swim.

Patches and Ollie are tired after spending the whole day swimming, so they lie down on top of the ice and fall asleep.

Pups are born at sixty pounds but grow to over 200 pounds in just six weeks. This is made possible by their mom's milk, which can be up to 54 percent fat.

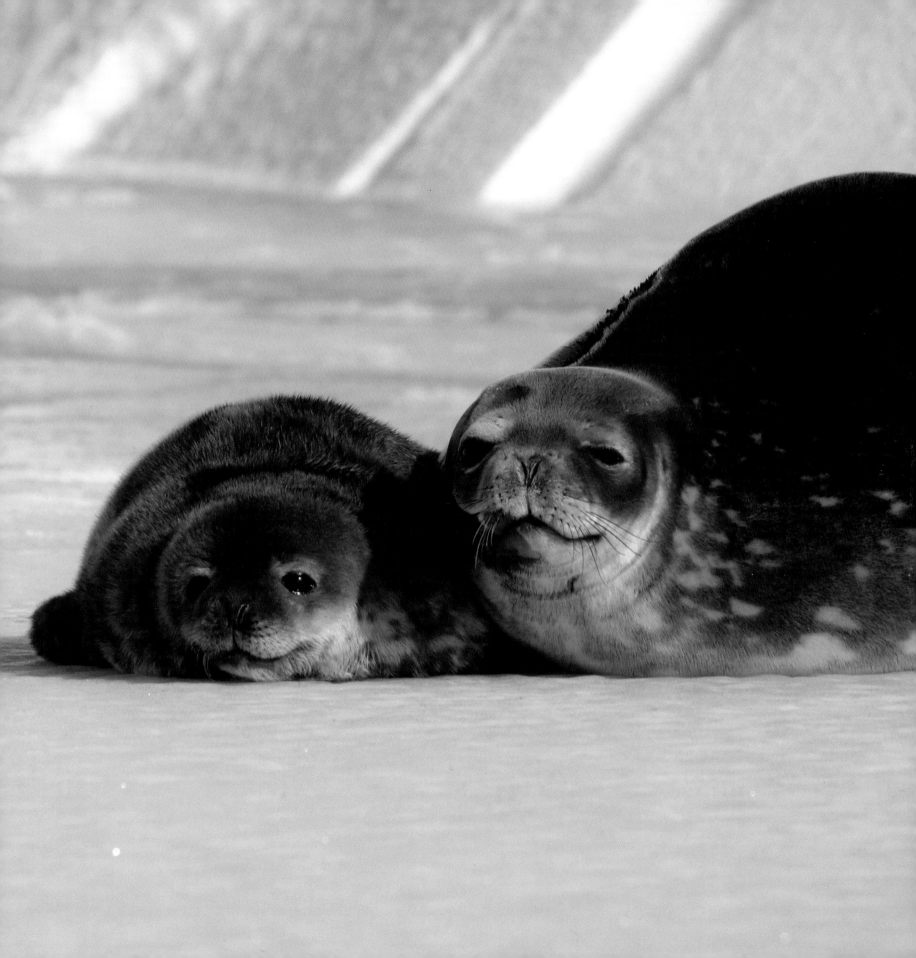

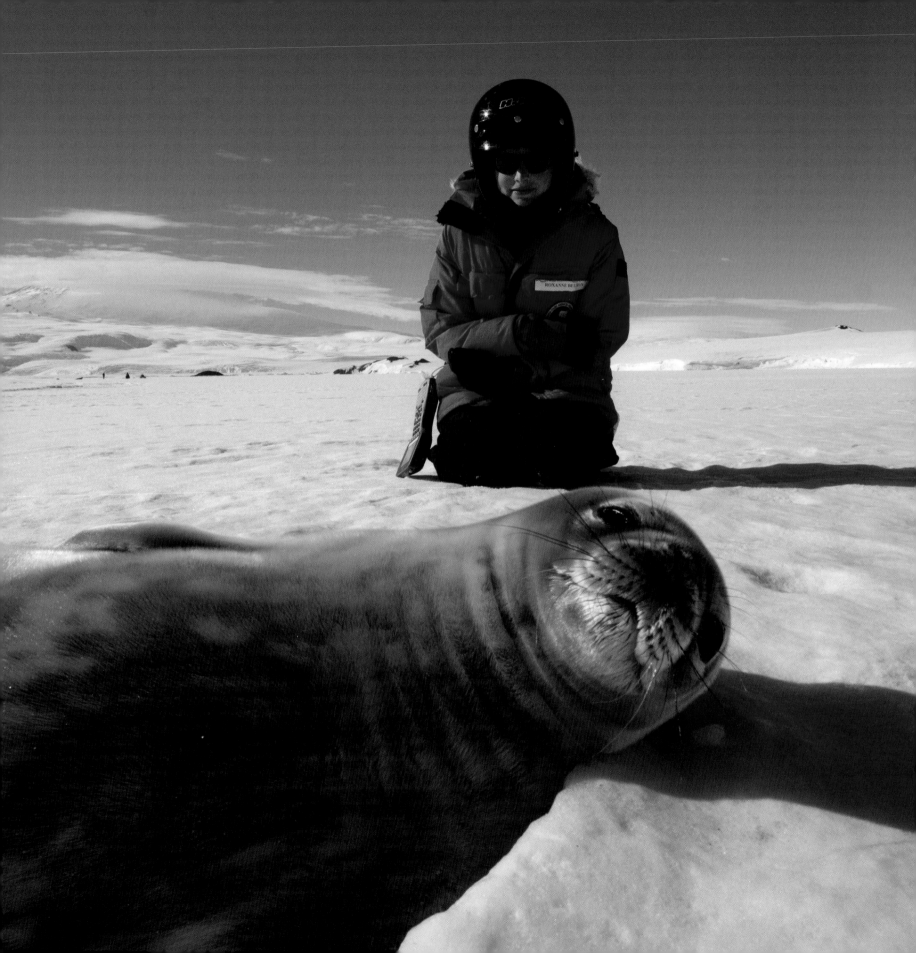

We are happy to see that Patches is healthy and gave birth to her twenty-second pup!

This was a good year for Weddell seals.

Now that we've found Patches, we can celebrate a successful field season. We're excited to come back to Antarctica and look for Patches again next year!

Many of Patches' pups have grown up and had pups of their own. Patches' oldest daughter is now 25 years old and has had several pups of her own. Patches even has great-grand-pups!

Acknowledgments

With love and gratitude to Robin Beltran, Philippe Beltran, Pépé and Mémé Beltran, Craig Robinson, Kay Robinson, and Brittany Robinson for instilling in us the insatiable desire to explore nature; to the mentors who taught us how: Jenn Burns, Dan Costa, Colleen Reichmuth, Greg Breed, Chris Reeves, Pete Raimondi, Ward Testa, Don Croll, Gage Dayton, Mark Carr, and the Long Marine Lab and Seymour Marine Discovery Center at the University of California Santa Cruz; to the people who have shared laughs and special moments on rookeries and haulouts around the globe: Amy Kirkham, Claire Nasr, Parker Forman, Rick Condit, Greg Frankfurter, Rachel Berngartt, Alex Eilers, Bobette Dickerson, Rolf Ream, Tonya Zeppelin, Caroline Casey, Luis Hückstädt, Brandon Güell, Skyla Walcott, Michelle Shero, John Loomis, and Tom Schaefer; and to those we've held close to our hearts despite the inevitable distance: Beth Jacobs, Rachael Parent, Marm Kilpatrick, Matt Cameron, and the UAF 2015 Grad Cohort.

Thank you to Jay Rotella, Bob Garrott, Terrill Paterson, and the past, present, and future Montana State University B-009 team for their endless efforts to tag and resight thousands of Weddell seals; to the many US Antarctic Program contractors who have facilitated our science and made our time on "the ice" so incredible; to Terrie Williams, Shawn Noren, and an anonymous reviewer for significantly improving previous drafts; and to the seals for helping us learn about their underwater lives.

Antarctica inspires scientists, explorers, writers, and artists from all over the world.

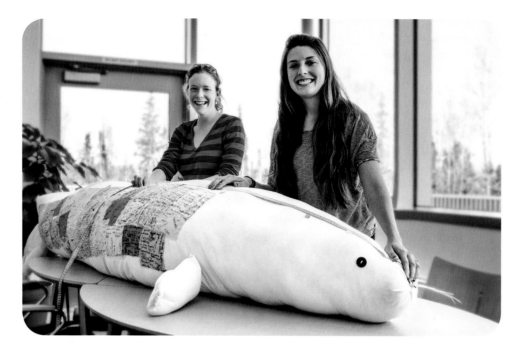

Roxanne Beltran (right) and fellow graduate student Amy Kirkham (left) created a life-size, stuffed seal named Patches that they have brought to visit 4,000 K–12 students in Alaska. Each student signed one of the fabric patches.

Thanks to the delightful K–12 students with whom we interacted over the past few years. Your enthusiasm inspired us to share Patches' story.

Dr. Patrick Robinson is the Director of the University of California Natural Reserve System's Año Nuevo Reserve. He has studied seals and sea lions around the world for the past 15 years.

Roxanne Beltran is a graduate student at the University of Alaska. She has travelled to Antarctica seven times for her dissertation research on Weddell seals.

Published by
University of Alaska Press
P.O. Box 756240
Fairbanks, AK 99775-6240

Cover and interior design by UA Press
Illustration by Jennifer Cossaboon

Photographs by Mike Pfalmer (page 3), Michelle Shero (pages 6, 7),
Amy Kirkham (page 8), Justin Maughmer (pages 20, 21), Kim Goetz
(page 24), Gregg Adams (page 28, 29), Chris Burns (page 34), and
Rachel Lee (page 46). All remaining photos by the authors. Research
activities were approved by the University of Alaska IACUC
protocols #419971 and #854089 and the Antarctic Conservation
Act permit #2014-003. Photographs were taken while conducting
research under the National Science Foundation grant #1246463,
Event B-292, under the National Marine Fisheries Services Marine
Mammal Protection Act Scientific Research Permit #17411.

Library of Congress Cataloging in Publication Data
Names: Beltran, Roxanne, author. | Robinson, P. W. (Patrick William),
author.
Title: A seal named Patches / by Roxanne Beltran and Patrick Robinson.
Description: Fairbanks, AK : University of Alaska Press, [2017] | Audience:
K to grade 3.
Identifiers: LCCN 2016056628 | ISBN 9781602233317 (cloth : alk. paper)
Subjects: LCSH: Weddell sealJuvenile
literature. | AntarcticaJuvenile
literature. | CYAC: Seals (Animals)
Classification: LCC QL737.P64 B437 2017 | DDC 599.79/6dc23
LC record available at https://lccn.loc.gov/2016056628

Production Date: 12.21.17
Plant & Location: Printed in Paju-si, South Korea
Job/Batch #80864/We SP121017

PRINTED IN KOREA
Second Printing